STARDUMB

ART BY JOHN DeFAZIO

STORIES BY DAVE HICKEY

ARTSPACE BOOKS

SAN FRANCISCO

BOOK AND COVER DESIGN BY KRISTIN JOHNSON

COVER ARTWORK BY JOHN DEFAZIO

ISBN: 1-891273-01-9

PRINTED IN HONG KONG

ARTSPACE BOOKS ARE AVAILABLE TO BOOKSTORES THROUGH OUR PRIMARY DISTRIBUTOR:
D.A.P./DISTRIBUTED ART PUBLISHERS, 155 SIXTH AVENUE, NEW YORK, NY 10013.
PHONE: 212-627-1999 OR 800-338-BOOK.
FOR INDIVIDUAL ORDERS, PLEASE WRITE TO ARTSPACE BOOKS, PO BOX 2407, SEBASTOPOL, CA 95473-24(
PHONE/FAX: 707-829-1651. ON-LINE ORDERS AVAILABLE. VISIT US AT WWW.ARTSPACE-SF.COM

ARTSPACE BOOKS ARE PUBLISHED BY SAN FRANCISCO ARTSPACE, A NONPROFIT VIDEO PRODUCTION
FACILITY AND PUBLISHING HOUSE.

*

*To the cosmic memory of John McCarron
and big thanks to my very Sagittarius friend Anne
[John deFazio]*

*

*To the memory of my muse and pal
Ralph the Beagle
connoisseur of the world's fragrances
the very icon of its liveliness and loveliness
[Dave Hickey]*

STARDUMB

1.

ARIES

"I went by the gallery yesterday."

"You what?"

"Went by the gallery. I was down there for yoga and I dropped in."

"Freddy there?"

"Oh yes. He came out and gave me the big huggy-huggy and took me back, so I could watch him twirl around in his designer chair . . . behind his Regency desk . . . talking on his head-set . . . to people in Milan."

"That's his job, Richard. Art dealers talk on the phone."

"Twenty minutes! I keep trying to leave, but he keeps waving me back. Asshole."

"Freddy's an art dealer, hon."

"Well, you couldn't tell it by me. I mean, Melinda's shit, Jesus. Is that art? And red dots on all of them."

"How many?"

"*All of them*, dammit! Every damn one! Also, I didn't see the blue painting."

"The blue painting?"

"The one from last summer. The one my mother liked."

"That one."

"It used to be up in his office but now it's not, and it's not in the storage either. I looked."

"Maybe he took it home. Freddy takes things home. It's a good painting."

"You're damn right it's a good painting and I think he sold it."

"If he sold it, he'd send me a check."

"So you say. I can't believe you trust that slime ball."

"The people I trust, my love, won't show my art. Anyway, Freddy's okay."

"Oh yeah, what about the fucking Baselitz!"

"Hey, he traded me for a Baselitz. Then he sold the Baselitz. Then he paid me. Where's the crime."

"Six months! That's the crime. For six months those Arabs had your painting. Freddy had the Baselitz. We didn't have shit."

"*Ars longa,* Darling."

"Look, I talked to him for half an hour and he never mentioned the blue painting. It's gone. I think he sold it, and I think you should call him."

"And say what? 'Hey, Freddy my husband thinks you stole the blue painting that his mother likes?'"

"Well, he sold it. I know he did. It's a great painting."

"It's an okay painting and maybe someone has it on approval. What am I going to do? Blow that?"

"I think you should call him."

"Well, I'm not."

"Well, at least call Jeremy."

"Jeremy who!?"

"Jeremy my friend from yoga. He works at Castiglioni. They really love your work."

"Nick and Rene do not even *know* my work."

"Well, they would if you called Jeremy."

"I'm going to work, okay? What are you doing?"

"Group and then gym."

"Get some coffee on your way back. Kenya."

"Kenya?"

"Right. Coffee from Kenya is my new thing."

2.

TAURUS

They were collectors. They wrote the occasional monograph and, in the dead of winter, chaperoned tours to Italy and Spain, but mostly they collected furniture and collected art and entertained people in their cavernous two-story studio off Columbus Circle. They liked to say they were a couple made in heaven—by the happy confluence of great aunts. His great aunt had the apartment and the wonderful cook, whose daughter was now their wonderful cook. Her great aunt had the wonderful furniture. It was French, mostly, except for a few English chairs and this elegant Federalist breakfront that constituted the anomaly of the collection. When the truck arrived from Connecticut with the furniture, she had them put the breakfront in the hall off the main gallery, where it was visible yet set apart from the European ambiance of the larger ensemble.

On an afternoon not long thereafter, subsequent to the estate being settled and the taxes paid, she was moving the breakfront about three inches along the wall to avoid a band of winter sunlight when she accidentally triggered a secret drawer. The drawer slid out to reveal an Italian leather box. When she lifted the box, there was a key under it. She used the key to open the lock and, lifting the lid, found the box to be brimming, quite literally,

with custom jewelry from the belle époque. She examined a few pieces, knowing what she was looking at, then closed the box, locked it, and placed the key in the tiny, antique pill box she always carried in her purse. She placed the box back in its secret drawer, closed the drawer and decided that she would not tell her husband about it. It was to be her secret. He had his secret collection, his young men (about which she knew). Now she would have her secret collection of jewelry, and things would continue as they had, since neither of them was much inclined to change anything, and they liked their life.

Twice a week they would entertain people in their home. Three nights a week they dined out. One night a week they went to bed early, watched the World Wrestling Federation on television, and, afterwards, had something like sex. These events took place Tuesday through Sunday. Monday night was set aside, sacrosanct. It was the night they worked on their invitation lists, which was their favorite thing to do, and, since it was cook's night off, they would take their notes into the kitchen and spread everything out on the chopping-block table. Before beginning, they would make themselves salmon and onion sandwiches and pour themselves large glasses of cold milk. Then they would go to work making crucial decisions about the social history of Manhattan to the accompaniment of the humming refrigerator.

In their view, the composition of an exquisite dinner party constituted connoisseurship of the highest order, and, after years of entertaining, their lists had achieved a level of Byzantine refinement unknown since the days of Edith Wharton and Ward McCallister. Each particular invitation list was compiled from a set of well-maintained master lists that were handwritten and heavily annotated on legal-sized, watermarked rag stationary. There

was a "furniture people" list, an "art people" list, a "country people" list, a "family" list, three "political" lists (local, national and international), a "celebrity" list (that changed with the season), and a "dreamboat" list made up of people whom one or the other of them fancied for one reason or another. One night they even made up a World Wrestling Federation list, but they never invited any wrestlers to dinner.

Their favorite, most subtle list, however, was their "get back" list. The people on this list had one distinguishing characteristic. They were friends with people they wanted to "get back" at—with people they wanted to "not invite"—and since every week there were literally millions of people in Manhattan who were not invited to their parties, they had devised this strategy so the people whom they did not invite would *know* they were not invited, because their friends, who *were* invited, were, in the judgment of their hosts, precisely the sort of people who would tell them.

Every month or two, they would have a "get back" party—an event that was always deliciously satisfying to them, but only in a metaphysical sense. The party itself was usually a chore and occasionally a disaster. Composed as these parties were on a negative principle, their positive composition was never quite what it should be. As a consequence, some of these evenings settled like a bad soufflé into deadly dullness. Others were quite noisy and posed a danger to the furniture. Even so, they regarded their "get back" dinners as definitely worth giving. Slights were redeemed, scores were settled and insults flung back in the face of those who gave them. Honor was at stake, and even though their parties were famously inclusive, the power to exclude had to be asserted in some visible, tangible way for that inclusivity to mean anything. It was an obligation that came with the gift of social arbitration.

Even so, the "get back" parties invariably left both of them grumpy and out of sorts, so the next morning, he would put on his tweed jacket and politely excuse himself to "take a little walk." She knew he was heading for the park to consort with the young men there, and that he would come home a little dazed but meticulously tidied up, his hair damp and recently combed. She never said anything. The young men were his secret. The moment he was gone, she would take down her catalogues and references books, open the secret drawer in the Federalist breakfront and take out the leather box. For an hour or so, she would sit at the little secretary in her dressing room and, in watery sunlight, catalogue her secret trove of antique jewelry in a little notebook with marbled covers. Then she would pack everything up, put it away and wait for his return. He was always back in time for lunch. After that they would take a little nap.

3.
GEMINI

The sky was turning murky blue-beige when they came out of the after-hours place in Chinatown. Steve, the limo driver, was taking a nap behind the wheel of his Lincoln. She knocked on the window. He ran the window down, and she shared a little bump with him, reaching through the window to hold the spoon under his nose. Then they headed uptown. After they dropped the artist off in Tribeca, she settled back into the soft leather seat and smiled one of her famous, triumphant, fashion-magazine smiles, enjoying the deserted streets and thinking to herself that she was, in fact, one hell of an art dealer. Not a *great* art dealer, perhaps, since she had more of an ear

than an eye, and not a *classic* art dealer, either, since she preferred selling to counting (That was her motto, "Sell don't count!"), but when the conditions were right, as they had been yesterday, when she could set the poetry of commerce in motion, as she had done, she could fucking sell some art.

It had been a beautiful autumn afternoon, perfect for an opening. The gallery had looked great. The art on the wall was a cut or two above average, and the artist had the sense to dress down. He arrived on foot looking like a Gen-X street person, which, naturally, made *her* look more powerful, which was good, since she had to sell the shit—and since she liked the way things looked, and the way *she* looked, and the way she felt, she sold a lot of it. People *always* wanted to buy. She knew this, so she would put on her serious smile, look into their eyes and mirror their desires, investing those desires with her own confidence and energy. Soon the sparks would fly. Then they would buy anything. Anyone would. She could sell anything to *anyone*—except to actors, who had always been a problem. Actors would put on their serious smiles, look into her eyes and mirror her desires, investing her desires with their own confidence and energy—and she would fall in love with them. Fortunately, New York was not Los Angeles, and there were not many actors to distract her from business, so a garden of red dots bloomed on the price list as the opening progressed.

Afterwards, at the dinner, the artist had been as giddy as a school girl. Sitting there like Louis Fourteen in a Corbu chair, in his faded *Joy Division* T-shirt, in his torn jeans and work boots, he happily drove the sommelier crazy about the wine, revealing himself to be just who he was (a labor lawyer's son from Grosse Pointe) but the Frenchman didn't mind a bit, because high spirits are infectious. *Winning* is infectious, she knew, and

most of all *money* is infectious, so they arrived at Larry and Jeff's giggling. They giggled all the way up the elevator, like bubbles rising in a glass of champagne, and stepped out into the living room feeling entitled to *everything,* entitled to the dazzling view that lay before them, to the perfect snacks, entitled, even, to the silver bowl of cocaine that Larry and Jeff kept on the Italian marble coffee table as a nostalgic offering to the lost spirit of the eighties.

Everybody hated the eighties now, because so many people had died, but *nobody* hates a silver bowl full of Peruvian cocaine. So they all did lines, just like old times, and got powder on their noses. They gobbled shrimp and other goodies seasoned with condiments and spices that Larry and Jeff had to explain in some detail. After an hour or so of coke, snacks and the view, they all set off for Chinatown. Before they left, however, she folded a hundred dollar bill and shoveled some toot into it—a small care package for Steve who was waiting downstairs with the car. She was good about details like this. People commented on it. They said it made up for her temper, and she hoped it did. Later, at the club, she introduced the artist to some actors whom she *knew* to be gay, although she nearly fell in love with them anyway as they all danced and shouted and dripped with sweat in the dazzled darkness.

Heading uptown through the gray morning in the back seat of the limo, she reviewed these events carefully and fumbled around in her purse, managing to locate her gallery keys but not her home keys, which she invariably mislaid. "Forgot my keys again, Steve," she said. "We need to drop by the gallery." "Yo," Steve said and hung a left, heading for Chelsea. A few minutes later, while Steve waited out in the car out in the brightening street, she took a seat behind her cluttered desk and surveyed the wreckage. She shuffled around for a moment, feeling for her keys and, not finding them, began

stacking things. Invoices here. Messages there. Checks over there. The pile had been accumulating for a week so there were a lot of checks, and even though she did not like to count, she ran the numbers in her head. Just to see. A hundred and seventy-two thousand dollars worth of checks. Loose on her desk.

She fucking *loved* it! And she loved just sitting there at six in the morning behind her desk. So she sat there for a few moments luxuriating in the brightness and whiteness of everything. Then, on top of the message pile, she noticed a call from Houseman in London, and London was what? Plus five. Hell, she could call now, and then call the people in Zurich, get that out of the way, and do some desk work before the staff came in. Why not? She could change here and maybe take a nap after lunch. She nodded firmly, pushed herself up and, with a quick step walked back through the gallery and out onto the street. She knocked on the driver's window of the Lincoln.

"Hey, Steve!" she said, "You go on. I'm going to stay here."

Steve ran the window down.

"Got daytime shoes?" he asked.

"Flats and heels," she said, "You get some sleep."

"Be dreaming of you, babe," Steve said and, touching his cap, drove away down the empty street.

4.

CANCER

She spent most of her childhood and adolescence looking out the window of her room, delighted to be looking and delighted with what she saw. She would take up her position two or three times a day, at different times

of day, and she was always amazed. The only things that surpassed the won-
der and glamour of the world that bloomed outside her window, in the yard
and in the street, were the visions she conjured up when she closed her eyes
in the moments just before she drifted off to sleep. *Nothing* could compete
with these. Even the image of herself paled beside them, when she finally
noticed the way she looked. One morning, when she was fourteen, her
mother had come into her room and installed a mirror over her dressing
table. She hated what she saw in it: a lovely young woman with silky red
hair and a pert cheerleader's countenance.

It didn't take her long to realize that she loved seeing and hated being
seen, because the girl she saw in the mirror, the girl other people saw, bore
no real relationship to the ecstatic presence behind her eyes. Witness-
ing their daughter coming into this knowledge from the outside, her parents
recognized a dreamer when they saw one. They encouraged her to become
an artist. For the rest of her life, she would damn them to hell forever for
their impertinence, because she was not an artist at all. Nothing she could
ever make or draw or paint could even begin to compete with what she saw
and what she dreamed. But she was a good girl and a good daughter so she
tried anyway. She worked at becoming an artist. All the way through high
school, through college and then through graduate school at a large Mid-
western university, she worked at it.

But she could not *get it*. None of her teachers told her anything that
made any sense, yet she kept feeling like she was just on the verge of getting
it. Finally, acknowledging to herself that she could never show anyone the
wonder of what she saw, she tried to show them what she *knew*—what she
knew herself to be, which was a creature who bore no resemblance to the

fresh-faced cheerleader she saw in the mirror. As a young woman, she always saw herself as an ancient crone, as a spirit old in the womb, like one of those witch-faced oracles who emerged through the smoke of sacrifices from the caves at Delphi to speak in tongues of miracles. She was much too knowing, however, too worldly and too well educated, ever to show anyone anything that corny. Instead, using a 9H pencil on translucent vellum, she made delicate, filigreed abstract drawings that sought to present some simulacrum of the intricate, evanescent, receptive mechanisms that were the agency of her visions—that were, in fact, who she was.

And people loved them, early on. Dealers and curators exhibited her drawings and people purchased them, but she was never interested enough in these people to follow through and never satisfied enough with her work to respect them for caring about it. She was, in her own mind, a searcher, sent out unwillingly upon a quest whose grail she could not even imagine. So she sought refuge: at an art colony in Maine, in a theory program at a museum in New York, in a post-graduate program in a southern metropolis, in studio situations in Virginia, Northern California and the Bahamas. Wherever she went, she would set up her drawing table and work, but the work did not change. The filigree of pale marks became larger or smaller, darker or lighter, but the filigree did not change. Retiring from her work, she would sit at the window and find the world beyond it as ravishing and incommunicable as it always had been.

Throughout these peregrinations and sojourns, she did, in fact, find a few supporters, but these were invariably creatures as lost and disconsolate as herself, so she made few friends and eventually ran out of programs to which she might apply. At this point, on the basis of her impressive resume,

she was hired as a drawing professor at a private university in a small town in Minnesota; and there, on a tree-lined street, she found a Victorian house with tall windows and window seats. At that time, the real estate market in rural Minnesota was severely depressed, so she was able to purchase it. Over the next few years, she restored the house to its pristine magnificence—made a showplace out of it—and because of this as much as anything else, she was eventually granted tenure at the university, even though all of her colleagues suspected what she knew to be the case: she hated her students, singly and collectively.

Without exception, she found them to be crude, brutal, ignorant, and insensitive. She let them know this and graded them accordingly. Even so, there were always a few masochistic souls who loved her classes. Beset by insecurity and self-loathing that confirmed her opinion of them, they sought to make a legend out of her, but she would have none of that. She hated them all, across the board. She found them disconsolate and dissatisfied, and she *hated* their dissatisfaction, hated the fact that looking out the window was not enough for them, that the world was not beautiful enough for them. Sometimes, when she let herself think about this too much, it would get to her. She would cry herself to sleep and, in that moment between sleeping and waking, she would have no visions at all.

5.

L E O

One evening about a week ago, I ran into Kristen at a sushi joint down on the beach. We were both alone so we sat together at the bar, stared out

the window at the sunset and chatted for a while. For a reason that I can't remember (probably the color of the light on the water), I brought up the subject of Michael Bowman, and Kristen, even now, thirty years hence and twenty years after Michael's death, got that look in her eyes.

"I'll tell you what about Michael," she said, staring at the dregs in her tiny, white teacup, "*Brad Pitt* is the pale copy. And *Michael* . . . well, Michael, he was the bright original."

Kristen would know. In October of 1968, I took her to the opening of Michael's first one-man show in Venice. But I didn't take her home. When we walked in the door, I started looking at the paintings, which were not really paintings at all, but something *better* than paintings: large, glamorous rectangular *surfboards*—icons in translucent resin that you could take home and hang on your wall. I turned to Kristen to say something about them, but Kristen wasn't looking at the art. She was looking at Michael who was standing on the other side of the gallery with a group of friends.

"Kristen?" I said.

"Huh?"

"What do you think?"

"I don't *think* anything," she said, "I wish."

"Wish?"

"I wish they all could be California boys," she said.

This was the last I saw of Kristen that night. I met Michael, however, and we talked about George Barris' Kustom Kar shop—talked seriously about it. Then, two weeks later, Michael and Kristen pulled up beside me at a stop light on Washington. They were in a little Austin-Healy. I waved, and they smiled madly, waving back—and so amazed was I and dazzled by the

clarity and perfection of their happiness in that moment that I couldn't even feel jealous, because the clarity, I knew, was all Michael's. In the company of ordinary folk, Kristen was brooding opacity incarnate, but Michael was not ordinary folk. He burned the mist off the breakers. So, even today, when I try to imagine what people might have been like in a more heroic age, before the onslaught of angst, psychology, anxiety and dread, I always think of Michael. There was no "why" in him.

Over the span of his short career, we met three times and not once during those encounters did I perceive in him a smidgen of doubt, nor even the inkling of a thought about which he might have had a doubt. His "look" changed considerably during this period—from surfer god, to Saville Row sophisticate to tattooed guru—but the way he looked at you did not. He would cock his head, give you that bashful grin and stare right into your eyes, like a very intelligent terrier: a solid, clear, blue-eyed *creature* with perfect blond hair that, when it was long, fell over his eyes, so he had to keep brushing it back.

He was born fatherless in 1945, in a trailer park in Huntington Beach. His mother whored out of the trailer, so he pretty much grew up on his own, on the water and on the beach. At fifteen, he was the white hope of long-board surfing, and, around this time, his mother disappeared. When he was sure she was gone for good, he transformed the trailer into a shop and started customizing Hobies. Pretty soon he was designing his own boards and Los Angeles artists, who knew art when they saw it, started buying them. They invited Michael to their studios and to parties in Venice and Beverly Hills. I didn't know him then, but I can easily imagine him standing in Billy Al Bengston's studio, or Ed Ruscha's or Peter Alexander's thinking

to himself, "Shit, I could do this!"

After our encounter at the stop light, I saw him next five years later. At that time I was living in New York writing for magazines. He called my apartment and invited me over to the St. Regis for tea, and tea was what we got: the china cups, the silver teapot, the scones, the whole tea-thing. He greeted me at the door wearing a beautiful, faintly Edwardian jacket, and sporting one of those goofy Prince Charles haircuts that only look good on good-looking creatures like Michael. These days, he said, he was working in London. He had a studio there and he had met Daphne. He made a gesture and Daphne rose from the couch. He was making paintings out of gauze now, he explained, and was about to have a New York show. He wondered if I would come to the dinner. I said I would (although, for some reason, I didn't).

Then we talked about California while Daphne sat there, poised like a porcelain doll. We talked about George Barris again, and again very seriously, and about Kristen, but mostly we talked about the freeways. Next to the surf, Michael missed the freeways most. He missed being crazy at three in the morning and "driving the wave," which was the great, looping freeway interchange between the 10 and the 405. The trick, he said, was to drive it at a steady eighty, not faster, not slower, without screeching the tires or hitting the wall. He could do it, he said, and I believed that he could.

As it turned out, Michael's New York show of gauze paintings was not a great success. He was cool enough for London, but way too cool for New York. Struggle was not in his vocabulary, nor was angst or even desire. Michael did presence. New York did absence, so he absented himself from that scene and I neither saw nor heard of him until 1978. I was sitting in a restaurant in Venice, California trying to negotiate something with Irving,

when I noticed this dude sitting at the bar. I could only see him from the back, but he was noticeable nevertheless: barefoot with long blond hair cascading down his back, wearing pink Day-Glo baggies and nothing else, unless the full body suit of tattoos counted as apparel.

I don't know whether I was looking because he looked odd or because he looked familiar, but I was still looking when someone shouted across the room. The guy at the bar turned his head and, by god, it was Michael! I went up to say hi and Michael was still his old sweet self: the tilted head, the crooked smile, and that perfect surfer gaze, clear and blue. I asked him what he was up to, and he said he had gotten out of art and into religion. I looked stunned, and he said, well, sort of religion—his own religion. It had to do with the surf and the mountains and, well, just the way he was. He had some followers, though, he said.

"And what do these followers do?" I asked.

"Well, you know, they follow me," he said, "They watch what I do and what I say and try to achieve some kind of enlightenment."

"And what *do* you do?"

"Me? Oh, I just do the usual. I do some waves, work on my boards, have some brews and do the occasional toot. They learn from that."

I had to laugh. I grabbed him around the shoulders and laughed out loud, "Well, *I* have certainly learned from you, Michael," I said. He laughed too and smiled his perfect smile again.

We chatted for a while longer. Then I went back to the table and told Irving about Michael's new religion. He said it sounded like a good idea. Three weeks later the naked body of Michael Bowman was found in a remote clearing in the St. Josepho Mountains. He had been shot through

the head with a large-caliber weapon. The weapon was never found, nor were his assailants ever identified. Nobody I know even went to his funeral, if they even had a funeral, and that was the end of Michael Bowman of Huntington Beach, California.

6.

VIRGO

Thai being the official food of American academia, Elizabeth Bennett agreed to meet me at the Ginger Tree Restaurant a few blocks off the Mid-vale University campus. It was snowing outside, and when she came through the door a few minutes late, shaking off the snow, Professor Bennett looked less like the dangerous academic revolutionary she was purported to be than a fifty-something version of Ali McGraw in "Love Story." She was carrying a large leather briefcase, a handbag of equal proportions and a plastic shopping bag from a local department store. Somehow, she recognized me or recognized me as a journalist. She walked over to the chair opposite and sat down heavily. Dropping her burdens around her.

"Let's get on with this," she said, "I've got kids to pick up in forty-five minutes."

I placed my cassette recorder on the table between us and turned it on.

DH: I am talking to Professor of Comparative Literature Elizabeth Bennett who is the founding director of Midvale University's new *Institute of Post Colonial Astrology*. How do you do, Professor Bennett?
EB: How do you do?

DH: I was wondering if you could tell our readers a little bit about the rationale behind your new institute.

EB: Well, that's a tall order, and the very word "rationale," I would point out, is a covertly patriarchal term, but I understand what you're asking and I'll try to answer. First, let me begin by reminding you that the goals of postmodern academic discourse are relatively stable, and that we here at the Institute of Post Colonial Astrology have no quarrel with them. The critique of bourgeois society, of proliferating late capitalism, hegemonic enlightenment rationalism and phallogocentric patriarchy are our goals as well.

DH: So how does your institute differ from other such institutes?

EB: Well, a few years ago, we here at Midvale took a stern look at contemporary criticism and came to these conclusions. First, the informing languages of most contemporary critique derive from post-structuralist revisions of Marxist and Freudian thought. These discourses have yielded their triumphs, of course, but we felt that the time had come to admit that these discourses are not only *post-structuralist,* but *post-enlightenment* as well, and as such they are almost inevitably, if only subliminally, infected by its atmosphere of mechanical rationalism. Moreover, both of these discourses are self-identified Eurocentric endeavors grounded in a profoundly western set of psychological and economic "realities." As such, they are unresponsive to the somatic global discourses that inform our present post-colonial reality.

DH: And astrology is not.

EB: Not at all. First, of course, astrology is a *pre-enlightenment* practice, totally untainted by its hegemony. It might, in fact, be regarded as the first *victim* of enlightenment rationalism, its first *bête noire,* as it were, the victim of a kind of Astrological McCarthyism. One might even argue that the

suppression of women, gays and working people by contemporary capital-ism *requires* the prior suppression of Astrology, which I hasten to point out is the *only* global, transnational and transcultural modality of serious critique and has been since the dawn of time.

DH: Well, this raises a practical question. Does Astrology work?

EB: That's the sort of question I would expect of a man, and, particularly, a man in your profession. Well, let me ask you this: Does Marx work? Does Freud work? Who knows! We are not, after all, dealing with masculinist empiricism here, with its counting and stacking and laboratory tests. We are talking about theoretical discourse in which the thing proven by the theory proves the theory. This perfect circularity is what distinguishes the discourse of Astrology, as well as those of Marx and Freud, from vulgar scientism, and elevates them all into the realm of socially redeeming speculation. The point here is to generate critique, not *truth,* and critique requires a complex methodology, an intricate terminology and no external modalities of hege-monic patriarchal control, no scientific tests or logical proofs. In the absence of these "controls," a truly global, multicultural, post-colonial discourse informed by a redeeming communitarian ethos might truly flourish.

DH: In the absence of a new world, in other words, you are proposing a new language.

EB: More an old language brought up to date, but I take your point. We see Marxist and Freudian analysis as having reached the point of diminishing returns. Everything from Elvis to menopause has been analyzed and theo-rized within the context of these impersonal dialectics, and what do we know? Do we know if our new lover will make us happy? Do we know any-thing about our personal characteristics? Have we derived any redeeming

insight from these critiques that might help us plan for the future or raise our children? Do we have any new ideas for the academic papers that are required of us to insure our professional survival? No.

DH: So, you are suggesting that the implementation of astrological theory and terminology, regardless of its other, socially redeeming virtues, will open up the field for thousands of new theoretical critiques, new magazines and university publications?

EB: Exactly, and, this time, the right people will be publishing them.

DH: Well, thank you very much, Professor Bennett. In conclusion, could I ask you what's your sign?

EB: Don't be a smart-ass, young man.

7.

LIBRA

I have no patience with people who complain about the narcissism and cruelty of the art community in New York City, those who despair at the anomie and disaffection that pervades this cultural ghetto. Such people, it seems to me, are dangerously misguided in their willful refusal to recognize, first, that shit happens, and second, that, amidst the population of human creatures on this planet, the percentage of bad, stupid, incurious and self-deluded individuals is amazingly stable from class to class, culture to culture and place to place. If these complainers would but acknowledge these simple truths, as many of us do, they could rejoice at the occasional happy accident. They could raise hosannas when some helpless, hapless creature adrift on the streets of lower Manhattan stumbles unwitting upon a comfortable

niche in its catacombs of desire.

The simple truth is that there is generosity in this world. As we go about the daily business of living here and being art people in the galleries and on the streets, at the delicatessens and in the bars, we routinely find ourselves gazing into the eyes of the mad and untalented, the ill-advised and misinformed, and when we do, we see ourselves reflected. So we take care of our own. Otherwise, there would be no way of explaining Billy Tilson's continuing presence in this world, or the affection and toleration with which people regard him, because in the history of the New York art society, I cannot think of another artist who has made a more idiotic sequence of deeply-considered bad decisions and still come out all right. For this very reason, Billy is cherished as a sort of talisman—as living proof of the fact that, sometimes, if you cannot find your thing, your thing will find you.

Billy, of course, was born to be an artist. They all are, and early on, he demonstrated a lovely talent for color and composition. He also manifested a sweet, if rather simple, artistic disposition. Sadly, though, Billy was born in Michigan, an American white boy in the late twentieth century, so rather than setting out to become an artist as he might have done in another place or in another century, he was encouraged to "major" in art at an American university where he could "explore his options." Moreover, since Billy's parents were ambitious for him, he decided to please them by studying art at a refined and stunningly expensive liberal arts institution located in the wilds of western Massachusetts where there is nothing lovely or well-composed or colorful, and the faculty likes it that way, since virtue is internal, and color and composition are the prime attributes of sophistic, cosmetic urban decadence.

Having grown up in Michigan and not understanding this at all, Billy simply assumed that his professors had his best interest at heart and listened to them. They would look at his lovely, colorful compositions and rub their chins. Then they would counsel him to branch out into something "less commercial"—to try something "tougher" and more "personal." They suggested that he experiment with installation and performance work, and never for a moment did Billy consider the possibility that these sincere professionals hated his easy talent. He already knew from "Sophomore Theory" that quality and talent were class constructions masking a malevolent system of power relations; and, since it was self evident to Billy that, at the present moment, these power relations privileged performance and installation work, he made the move, feeling that he would have been foolish not to.

He became gay for much the same reason. Once he learned that sex and gender were discrete conceptual categories and that sexual preference was, in essence, an idiom of political commitment, he decided that, since he wasn't having sex anyway, he would be much better off not having radical gay sex than not having vulgar, violent heterosexual sex. Thus Billy Tilson graduated from this wonderful liberal arts college as a militant gay installation/performance artist. During the summer after graduation however, as he was plotting his assault on the New York art world, it seemed to him that militant gay installation/performance artists were rather thick on the ground. (This was the early eighties.)

Also, it seemed to him that most of the gay people he knew in New York were flouncing around in the painting-and-object world of commercial galleries. The folks running the museums and kunsthalles (where performance/installation artists like himself plied their craft) seemed a fairly

straight group of folks to him. Here again, he was wrong. Most of these people were *not* straight. They were only square, but Billy Tilson was behind the curve at this particular stage of cultural assimilation. He had never met a square gay person, so the "gaydar" he had refined to detect fellow homosexuals in the hothouse atmosphere of liberal arts education in western Massachusetts failed him ignominiously on his exploratory visits to New York. As a consequence, he moved into a little loft in Manhattan, which he couldn't afford, and introduced himself around as a militant, heterosexual installation/performance artist dealing with issues of late-capitalist production and dissemination.

Immediately thereafter, he started working the system of power relations he had learned to perceive beneath the veil of rampant fetishism and false consciousness, and, knowing that the personal is political, he started getting personal with some political people, setting his sights first on Bethany, whom he met at gym. Bethany worked as a curatorial assistant to Miriam Miriami who was senior curator at The Big Museum, which, at that time, was the *ne plus ultra* of militant installation/performance art, gay and straight.

He started off having blended fruit drinks with Bethany at the juice bar next to the gym. After a week or so, he invited her to his studio, and she seemed to like his work. Then he got a tattoo on his forearm (one of those old-time TV test patterns with the Indian chief in the middle) and she seemed to like that too. One morning not long after that, during his weekly cover-to-cover reading of the Village Voice, he noticed that Miriam Miriami was giving a lecture at The Big Museum two days hence and saw his chance. At the gym that afternoon he asked Bethany if she wanted to go with him to the lecture. Bethany looked at him, pumping away on her bike and sweating

profusely. "Hey, why not," she said, "Come by and we'll walk over." So Billy Tilson showed up at Bethany's at the allotted hour, and, as they walked over, he got the bad news.

"It's okay if you come along tonight," Bethany said, "I mean, you're an artist and I like your work and all that, but you know that Miriam and I have this relationship, right?"

"Oh yeah," Billy said, "I'm cool with that. I just really respect both of you and what you do."

To this day, Billy doesn't remember one word of Miriam Miriami's lecture. He remembers sitting there looking at Miriam in her gray suit, in all her ordinary ordinariness, trying to get his head around the idea that she was a lesbian. He remembers looking over at Bethany in her sweater set, in all her suburban suburbanity, trying to get his head around the idea that *she* was a lesbian, too, and making it with Miriam. He remembers sitting there wishing with all his heart that he was still gay, too. It was the blackest hour of Billy Tilson's life, although afterwards, at least, Bethany had enough pity on him to ask him along for dinner. She even introduced him to Miriam, who was decidedly chilly toward him until Bethany sat down beside her at the Indian restaurant and gave her a big, affectionate hug. There were about fifteen people at the dinner. Billy found himself seated at the foot of the table with two young art installers from The Big Museum who were installation artists, too.

The three of them talked for a while about the critical implications of insurance claims made for damage to installation art that was made out of *objets trouvé* that were already fucking damaged in the first place. Walter Benjamin was mentioned, as was Pete Townsend, but Billy found his attention

drifting. He thought about those lovely drawings he used to make, the hours he had spent on them, berating himself for wasting his time so frivolously, when he could have been working the system. Then, in a twinkling and completely by accident, after all the disasters of the day, Billy's moment came. As they were all sipping their after-dinner de-cafs, the Indian waiter whose cultural radar was still calibrated to New Delhi values, mistook the foot of the table, where the guys were, for the head of the table, where the women were, and left the check by Billy's plate.

The two art handlers immediately handed Billy some cash to cover their vegetarian curry and split. Another couple who were leaving dropped a couple of twenties on the pile. Everybody else, as they left, tossed in some currency and Billy stacked the bills as they collected. Miriam and Bethany were the last to leave. Miriam handed him some cash and he said. "Y'all go on, I'll sort this out and leave a tip." Bethany waved as she went out the door, leaving Billy sitting at the table counting currency. He set aside the amount of the bill. Then he set aside fifteen percent for the tip. Fifty dollars remained. Billy looked at the money and thought about his humiliating day.

He thought about the depredations of late capitalism that he experienced daily, nay, hourly, and the necessity of exploiting its evil, profligate generation of surplus value. The revolutionary confiscation of this cash, Billy decided, would constitute radical performance art at its most covert and refined. It would, in fact, constitute a genre all it's own, a radical mode of resistance. You dine out, working the system and exploiting its covert power relations, then collect the money these careless bourgeois herbivores toss onto the table for their food. You pay the real working people who

produce the food, tip the waiter and keep the rest for the revolution and the rent.

This is how Billy Tilson discovered the subversive artistic strategy that he has been practicing for the last fifteen years. It is no longer as covert as Billy imagines it to be, of course, but this in no way detracts from the performative aspects of the action's revolutionary intent. These days, to assuage Billy's anxiety when the check arrives (lest someone not "in the know" volunteer to collect the bill), some old timer always insists that Billy gather up the money. Virtually everyone at the table, of course, has long since calculated the little percentage they will leave to help insure the continuation of Billy's artistic career. Sometimes Billy almost knows this himself. He will stroll out of some restaurant after a dinner, maybe sixty or seventy dollars to the good, look at the bright lights of the great city around him, at the people rushing past on the sidewalk, and he will think to himself that it's not such a bad world after all.

8.

SCORPIO

I'll say this for Chubby Bascomb, he isn't cheap. I had been working for him for maybe three weeks when he sent me to courier the Mayan cylinder, but that didn't matter to Chubby. I worked for Bascomb Fine Arts, a class operation, so a limousine showed up at the gallery to take me to La Guardia. A first-class ticket flew me to Dallas, and another limo was waiting to drive me over to Art Crating and Shipping, which is located in an anonymous building in a landscaped industrial park not far from the

PASSIONATE AND REBELLIOUS SCORPIO PEOPLE OFTEN HAVE A SECRET ROMANCE WHICH FLOURISHES BEHIND GLAMOROUS CURTAINS!

airport. As a consequence of all this pampering, I was feeling pretty fat and happy as I walked up the sidewalk. This was just as well. When I opened the door, a big guy in khakis and a blue short-sleeved shirt was standing beside the desk screaming at somebody on the telephone. He had a helmet of kinky black hair, thick black eyebrows and very little brow between them. He looked like a goombah from upstate, which, as it turned out, he was.

He slammed the phone down and acknowledged me.

"Hey, kid," he said, "You from Chubby?"

I nodded and handed him my card.

"'Derek,'" he said, reading the card, "'Derek Chambers,' Jeez." He looked up at me and stuck out his hand. "Ernie Restante" he said, "and, Derek, you got a choice. You can sit on your butt for a couple of days over at the Mansion over on Turtle Creek, or you can come take a ride with me. Get the cylinder."

"I'll take the ride," I said, because Chubby had instructed me to go with Ernie wherever he went. Chubby had the cylinder sold, and he didn't want anything happening to it.

"Got luggage?" Ernie said.

"Just this."

"Well, grab it and let's roll."

Twenty minutes later, we were rolling southwest out of Fort Worth on Texas 377 in the luxurious cab of Ernie Restante's eighteen-wheeler. It was like sitting in the third balcony of a Broadway movie house. Perched vertiginously aloft, I stared almost directly down at the pavement that was swooshing under the truck. When we got into a cruising gear, Ernie slammed in a Replacements tape and cranked it up to stun.

"Old times," he shouted over the tape. "Except for gigs like this, I don't drive much anymore. Here, take one of these!"

He held out an enormous paw. There were five or six green spansules in it. Judging from his tone, I didn't seem to have a choice, so I took one. It was the first speed I'd taken since my Northern Baroque exam at Providence, but why not? I felt like a complete dork in my tassel loafers and gray slacks, in my Brooks blazer and nice white shirt and Italian tie. The Replacements were battering my ear drums. West Texas was rolling under my feet. There were cows in the fields through which we fled. After a while, I took off the tie and put it in my pocket.

We were an hour or so down the highway and listening to The Dead Boys when Ernie turned down the volume and said:

"So you're an art guy, huh, Derek?"

"Yeah, I'm an art guy," I said.

"Me too," Ernie said, "Art and books, those are my things, which is why I started Art Crating and Shipping. It's kind of a sideline and kind of a front, too, but it's not completely bogus, because I dig art, read everything I can about it." He reached behind the seat and pulled out a battered copy of *Manet's Modernism* by Michael Fried. "You read that?" he asked.

"Yeah," I said.

"It's mostly bullshit, but some okay," Ernie said. "And, my friends, Jesus, what fucking animals. They're into *en-ta-tayn-nahz!* They go to Vegas to see Buddy-fucking-Hackett, and what's *that* about? I can't believe it. Me? I say, fuck Vegas. I'm Italian. I take the wife, we go to Italy. To Venice. I got a friend there lets me stay in his palazzo, and even my friend says 'Ernie, you're welcome here, but you got family in Palermo. Why aren't you in

Palermo seeing your great aunts?' I say, 'Fuck Palermo, and fuck my great aunts,' because, trust me, Derek, Sicily has got shit for paintings. But *Venezia*, she got some paintings! But this old gonif just looks at me. He's got a fucking *palazzo*, you know, and a dock on the Grand Canal with a power boat tied up to it, and he's never even seen the Tintorettos, never seen the fucking Tiepolos. He don't even go to *church*, this guy. He goes to *Vegas*... to see Buddy Hackett. Jeez."

"I got friends like that," I said, trying to think of one.

"So you know, then?" Ernie said, "You're an art guy like me. So you understand. You know why I like shipping this shit around, crating it up and delivering it. Doesn't matter what: old, new, Surrealist, Impressionist, Fauve, whatever, just so it's the quality shit. You got to be compartmentalized to do it, though. You treat it as a goof or you go postal. Because, trust me kid, the art world is all crooks. Chubby-fucking-Bascomb, your boss and my old pal, is a fucking *crook!* Ernie Restante, he's a *criminal*, and there's a big fucking difference I can tell you. Crooks think they can get away with all this little-bitty shit, so if I take this business seriously, I break Chubby's legs a time or two, all the sneaky shit he pulls. But, hey, he lets me haul the quality stuff. Just last week I'm riding along with four Joe Goode milk bottles right where you're sitting, so what the hell? And I'll earn some dough tonight, too, but not from the cylinder. The cylinder is a push. I just want to see it."

Ernie fell silent at this point, and I sat there thinking about Ernie breaking Chubby's legs. How would he do it? With an aluminum baseball bat, I decided. This made me extremely aware of my own legs which, for the moment at least, were blissfully and completely intact.

At sunset, we rolled into San Angelo on Texas 67. The sky was a

lipstick-red dome. Beneath its immensity, the town looked small and blanched as it slipped past our windows. About twenty-five miles further west, out on the bald prairie in the absolute middle of dusty fucking nowhere, we turned south on Farm-to-Market 915.

"You're looking for a little sign that says Red Roof Ranch," Ernie said, "Should be somewhere in the next ten miles. On your side. There'll be a cattle guard."

It was nearly ten miles, but we found the sign and Ernie steered the big truck over the cattle guard onto a dirt road. Soon we were heading west in full darkness under a billion stars. Ernie didn't say anything. He just drove. Once, he gave a little, one-finger wave and I glimpsed a Mexican in a straw hat standing off in the mesquite with a rifle under his arm. After about an hour, the dirt road curled up over a ridge, and, reaching the top, we suddenly found ourselves looking down into a small valley where about fifteen trucks were parked with their lights on. A few of them were vans, but mostly it was big rigs like ours, parked in two rows facing one another. Between them, a strip of graded road ran for about half a mile along the swale of the valley, its surface illuminated by the headlights. At its south end, the grading ran for about a hundred feet into a small hill that had been cut out to accommodate the road, making a little cul-de-sac canyon. Two yellow bulldozers crouched atop the hill on either side of the cut.

"What the hell is this?" I said.

"Capitalism in action," Ernie said. He guided his rig down into the valley and pulled into a slot in the east row of vehicles. Leaving the lights on and the diesel rumbling, he opened the door and climbed down.

"Meet me at the back," Ernie shouted, and by the time I got there, Ernie

was deep in the empty trailer, working on the cab-side wall with a power screwdriver. I climbed into the trailer and he handed me a tall panel. "Lean this outside," he said. He was removing a false wall. Behind it, there was a hidden compartment about five feet deep. When we had the panels out, Ernie climbed down and walked back to the front of the truck. He lit a cigarette and looked at his watch.

"Twenty minutes," he said, so we stood there. A couple of guys came over from the other trucks to say hi to Ernie, but Ernie himself stayed put. Between visits, he explained that, because he was a "made" guy, he didn't have to walk around making nice. Twenty minutes later, we heard the roar of the plane, then, suddenly, it was right there in front of us, big and surprising, an old DC-9 painted olive drab, coming in low and fast, rushing past us in the headlights, wobbling. It hit the ground hard with a screeching crunch, bumped half-skewed about three quarters of the way down the grading and stopped. Two guys driving forklifts headed out to greet the plane. The truckers started turning off their headlights, except for the ones on the plane's door which opened immediately. Three Mexicans dropped a ramp from inside and came strolling warily down it. One of them carried a clipboard. The other two were carrying automatic pistols with long, curved, military clips.

"Stay here," Ernie said and strolled casually out toward the DC-9 where they were already off-loading bales of weed in a very efficient manner. Even so, it took the rest of the night to empty the cargo bay of the plane. Somebody would talk to the guy with the clipboard and hand him a brown, legal-sized envelope. Clipboard would check his list, check the envelope and call the guys with the forklifts. They would off-load the bales and drive them over to one truck after another. The trucks would leave as soon as they

were loaded, pulling up over the rise and disappearing. We were last in line, so we had a long wait. I found myself wishing I had another green pill. When Ernie finally came back, hanging off the side of the lead forklift, the sky was purple. The Mexican guys helped fit the bales into the hidden compartment. Ernie and I reinstalled the false wall, and Ernie closed the trailer, locking it with a combination. Then, he turned to me.

"Come on," he said, "It's art time." This time, we walked out to the plane together. I stood there while Ernie jabbered in Spanish with Clipboard. Clipboard yelled something into the plane. A little guy wearing white peasant pants came scurrying down the ramp carrying a small aluminum crate. Ernie handed Clipboard another envelope. He checked it and nodded to the guy in the white pants, who handed the crate to Ernie. Ernie set the crate on the gravel and pulled the power screwdriver off his belt. While he was unscrewing the box, the Mexicans started pushing the DC-9 into the cul-de-sac at the end of the runway. When the DC-9 was totally enclosed by the sides of the artificial canyon, the bulldozers cranked up and started pushing dirt down over the old plane, burying it, like a dead brown bird. While this was going on, the sun broke over the ridge behind us and lit the 'dozers up bright yellow. They looked like giant locusts in their gauzy, flame-shaped plumes of dust, and since it was the scariest, weirdest thing I'd ever seen in my life, I turned to say something to Ernie, but he was oblivious. He was holding the Mayan cylinder in his hands, gazing down at it in wonder.

"Would you fucking *look* at this," he said, turning the cylinder in his hands. "Come on, Derek, *look at this!*" he said, so I stepped over and looked. "You see right there, Derek? That's the Jaguar King. He's the head

dude, so he's got to do this blood sacrifice for his kingdom. And right there, coming out of his jaguar cloak? That's his pecker . . . his shlong. He's had to pierce it with a knife and run this purified strip of cloth through it. That's the ritual, so his blood will flow into this bowl and save the Mayans' civilization. See? There's the blood coming down, and there's the bowl."

"Yuk," I said.

"Yeah," Ernie said, "but it's not so weird, really. You been to Sicily, kid, it ain't weird at all." Grasping the cylinder in both hands, Ernie Restante suddenly lifted the ancient vessel above his head to catch the morning sunlight.

"Beautiful," he murmured, gazing up at it. "The damn thing is fucking *beautiful*," he said again, "and older than a bastard."

9.

SAGITTARIUS

When I walked into the high-stakes salon, she was sitting at the poker table, folding a hand and tossing in her cards. She saw me immediately, nodded, and evidently told them to deal her out, because all the guys at the table looked disappointed—and not because she was losing. She had a lot of chips in front of her, but you got the impression they would rather lose with her in the game than win with her gone. She flipped a purple chip to the dealer, gave another one to the waitress, racked up the rest of her winnings and rose to her feet. The room paused for an instant when she did, and, as usual, I was amazed, because that always happens.

She was wearing white running shoes, black jeans, a Knicks T-shirt and a black Helmut Lang jacket. Her black hair fell straight down, spilling over

the shoulders of the jacket, and, in truth, if you looked at her carefully, she was not really that beautiful. She was striking, though, striking in the extreme, like a really elegant vampire with a Lady Liberty profile and lots of smarts behind the eyes. The feeling she caused in me was distinct, absolutely special. Whenever I saw her, it wasn't like I wanted to own her, or fuck her, or marry her or anything like that. I just wanted to *be there* where she was, in her presence, looking at her and laughing with her, feeling the vibe. She was my favorite vacation spot, better than Maui or Victoria Falls or Old Faithful or any other natural wonder.

She felt something like that too, or said she did, and we had a history. One night back in the eighties, after a gallery opening, we actually had sex, and there was some chemistry there. Unfortunately, there was a lot more chemistry up our noses and, at the time, we were both embarked upon our own dark journeys, but it was very nice. Afterwards we sat in the dark and held hands, knowing that we had both been holding back, that it could have been fucking great—that we could have cut a swath through the universe and blown the doors off of dangerous romance—knowing, too, sadly, that neither one of us had the time or energy to do it. Ever since then, we've had this sweet thing going on, based on nostalgia for the romance we never had. We're comfortable together and relaxed in the wonderful assurance of being with someone who likes you too much to break your heart. That's our thing, and it's real enough that most of the hot sex I've had in my life was about half as sexy as having her come running up to me in that high-stakes poker room, in front of all these international whales she'd just hammered, to give me a little kiss, tuck her hand under my arm, and lean against me as we strolled out together. It really felt good and she knew it.

Blackjack

SAGITTARIUS PEOPLE ARE ATHLETIC AND WELL-DEVELOPED. THEY ARE INCLINED TOWARD REVELRY AND BURNING THE CANDLE AT BOTH ENDS!

"Who sent you?" she said the moment we were out in the casino proper.

"You send me, baby" I said and gave her arm a squeeze.

"I mean it, asshole," she said, "I want to know if you're *worried* about me?"

"I'm worried about me," I said, "You look great."

"Well, you want to see what *really* looks great?" she said, "You think you have the balls to be completely blown away and struck dumb?"

"I think I do," I said.

"Then follow the princess," she said and struck off around the roulette tables. I followed her but she kept pulling away. When I finally caught up, she was standing in front of a bronze elevator door digging in her purse. She pulled out a card and stuck it into a slot in the facing.

"You get one of these cards when you're an Official Little Darling of the Universe," she said. The bronze door slid open and we stepped into a large glass-walled elevator. She stuck the card into another slot and pushed the uppermost button. Then, without speaking, we both stepped to the very outermost edge of the cage and stood there, side by side, with our noses to the glass, like we used to do at the Hyatt in Atlanta. The elevator sighed, mumbled, and shot straight up, fifty-two stories in one smooth, accelerating motion. Vegas fell away like a dazzling, plunging neon carpet. Our stomachs fluttered, the backs of our knees tingled and we both went "Woooooooo!" all the way up. The door opened behind us onto a large empty hall done in the manner of Caesar Augustus. The floor was covered with a mosaic depicting a pattern of fish and storks in brown and blue tiles. The walls were creamy marble articulated with period ornament and punctuated with half columns.

"The executive offices," she said, gesturing me out of the elevator.

"How nice," I said.

We hadn't walked more than an eighth of a mile before we came upon an alert, blond security guy sitting at a counter beside a Palladian door.

"Hey, Miss Archer," he said.

"Hey, Jim," she said, "The boss in?"

"Tahoe," Jim said.

"Well, can I show this famous art critic my painting?"

"You certainly may," Jim said, "Just sign here."

We signed and Jim triggered the door. "I released the office door, too. Just close it behind you as you come out."

We walked through an outer office then through another Palladian door into what would have been a Roman atrium if it hadn't been on the fifty-second floor of a Las Vegas casino. There were three glass walls, pinned by columns, overlooking Las Vegas. There was a glass ceiling too, which I suspect was retractable. Her painting was on the single solid wall facing an antique desk that was silhouetted against the night.

"Yikes!" I said, "That's a damn good painting."

"It's a fucking *great* painting," she said.

"Well, that, too, of course."

"And do you know what that means?" she said.

"Uh, I dunno, I guess it means La Archer painted it?"

"No way. It means Mack Simon is one lucky fucker. Because great or not great, I get my two hundred grand."

"Less commission," I said.

"*After* commission," she said.

"Ah." I said, "The lady ascends."

"You're damn right." she said. "Now, tell me who sent you here. I'm serious."

"Seriously, then, nobody sent me."

"But people talk to you."

"They talk but I don't listen because I love you."

"But you came here anyway because you think I'm gambling away my so-called future."

"I came because I was in Los Angeles and you were here. That didn't seem right."

"You're right. It wasn't right," she said. "And I'm really glad to see you. But I'm also pissed. People are fucking with my life. "

"I will convey that to those whom you are pissed at."

"Well, convey this. The day I installed this painting I lost every cent I made from it at the baccarat table."

"Good," I said, nodding. "That's good. This will certainly allay everybody's ungrounded apprehensions."

"Then tell them this: I won *twice* that much the weekend I came out here to negotiate the commission."

"The point being . . . ?"

"The point being: *You never can tell!*" she said, "The point being: *It's not me!* It's me and the world coming together. I go into my studio. I sit down at the poker table. I do the same things I always do, with my whole heart. Sometimes I win. Sometimes I lose. That's the point. What's in your head is in your head. What's in the world is in the world."

"But your head is in the world," I said.

6 2

"Not mine, buster. My head, is full of bullshit theories, strategies, hopes, aesthetics, desires, tactical risks, fallback positions..."

"And the world...?"

"...is full of *stuff!*" she said, "It's full of paint, canvas, horses, cards, dice, diamonds, basketballs, greyhounds, turtles, stuff that you *can't tell about*, that doesn't even have rules, only tendencies."

"So?"

"So sometimes the world does what you want it to. You win, but it's not your doing. Sometimes you do the same thing. You lose. That's not your fault either. You do your best every time. Don't you?

"Every time," I said.

"But sometimes you lose, right? At six figures a painting—good or bad—bullshit or brilliant—I start thinking, well...that I'm winning...but I'm not. I'm only succeeding. I'm winning in other people's heads and that's not winning—that's winning in theory—and *theory*, 'chuco, is poker with no spots on the cards. I say it's four aces. Everybody in Cologne says, 'Jah! Four aces! An amazing masterpiece, Fraulien Archer.'"

"So you want to lose for a change? You have self-loathing? Impostor anxiety? Low self-esteem?"

"Don't you wish," she said. "I want *victory*, you asshole! I want that feeling when the weird stuff in my head and the hard stuff in the world are humming together, just for a blink, and I want to *touch* it...in the studio... in the bedroom ... at the tables. I mean, those sissy fucks are *right* to be worried! I want real-time, edge-of-the-world, hard-core, rock-and-roll *winning!*"

"Well, then," I said, "would the lady, perhaps... fancy a fuck?"

She had been pacing around the big office, but she stopped when I said this, froze and began turning slowly toward me. I felt a flicker of cold panic because I thought I'd blown it, that maybe I'd hurt her, but she was smiling madly when she faced me.

"That's *such* a good idea!" she said, shaking her head and really smiling now, almost laughing. "You are *so* perceptive!"

"Well?"

"Well, *of course*, Butthead, but just one thing."

"What one thing?" I said.

"Well two things, really. We go eat afterwards and then go gambling."

"What if we win?" I said.

"We'll cross that bridge when we come to it, " she said.

10.
CAPRICORN

William Jackson Manfredi is dead. The great museum lost its helmsman in an instant, of a heart attack, while he was jogging around the reservoir. Today, attended by his wife and children, surrounded by a pride of suits and a fluency of dowagers in designer mourning, he is being laid to rest in a country churchyard in Connecticut, hardly ten miles from the horse farm where I was born and grew up to be who I am—instead of William Jackson Manfredi, whom my parents would have much preferred. And I should be there at the funeral, I guess. Maureen sent a card inviting me, and Willie, his oldest son, who works on Wall Street, called to assure me that I would be welcome. "We all loved Billy Jack," he said, and that's true, but I'm

worried about Clint, the youngest. He is eleven going on gay and can't quite fathom why I make him nervous. Clint, I think, can do without me sniffling by the grave, swaying like a reed in the wind, haunting him like the ghost of funerals yet to come.

So, I am mourning Billy Jack Manfredi here in the darkness and coolness of a swish little midtown *boîte* called Cocteau's Parrot where we first did plight our troth, where we would meet for drinks when he was busy uptown and I was busy down. I am sitting at our table, in my chair, with a large glass of expensive scotch in front of me, remembering. I met him twenty-five years ago last June. He was a junior administrator at the great museum then, without much prospect of advancement. I was a prep-school queen applying for work at the great museum because I wanted to "do something in the arts." He sat there behind his polished desk, solemn and even a little stolid in his dark three-piece suit, fingering one sideburn of his clunky, Bobby Kennedy haircut. He gazed at me thoughtfully as I presented my case. Finally, he said, "I think we might be able to find a place for you Mr. Dennis. Could we, perhaps. . ." He flipped open his appointment calendar, "have lunch next Wednesday. . . at Cocteau's Parrot?"

I nearly fainted, and that was it. For the next twenty-five years, whenever we were both in town, we spent two nights a week together in my little apartment down on Jane Street amidst the fabric and the feathers. (I am an old-school, West Village queen, no brushed-aluminum Euro-chic for me. I even have a framed *Fantastiks* poster, inherited from a previous tenant.) The peculiar thing, when I met him here that Wednesday—he in his three-piece suit, me in my Gucci kicks and cashmere pullover—is that we really fell in love. We were perfect right away. There were never any fights or misunder-

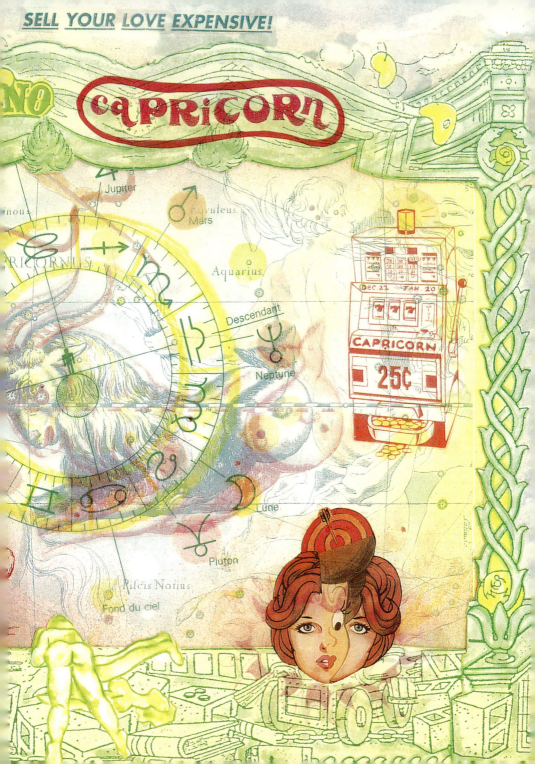

standings or negotiations, and nothing ever passed between us about "issues"—about being gay or being straight or being bi—nothing political or psychological. Billy Jack came from another place. To him, we were just two humans on the earth. We talked about art and music, about his family and his job, and about my jobs (I now design commercial interiors).

And, he *always* told me that he loved me, in that clunky, pseudo-banker way of his. Even on that first afternoon, he told me that he thought he could love me, and it amazes me even now that someone who seemed so buttoned-up could be so open. He was quiet about it, of course, a bit flat-footed, and not the least romantic, but said what he felt, and told me things I'd never heard before. Mostly, we talked about our childhoods, and the moment we broached the subject, it was immediately apparent that I had had the childhood Billy Jack required and that he had had the childhood that I desperately wanted. This contributed in a major way to our compatibility. We were, each of us, who the other should have been. I had the whole Connecticut thing: the horse farm, the Prussian blue cabinetry, the hand-woven throw rugs, the dancing classes and prep schools, the terrifying, freezing afternoons thrust out onto the muddy pitch with a lacrosse stick into a pack of steaming animals. Billy Jack knew nothing of such exotica, and I loved explaining Connecticut to him. Ultimately we would call it "deconstructing Martha Stewart," but it started long before that.

After Martha arrived on the scene, however, it was a lot more fun. We would sit on the couch with a couple of drinks watching her television show with me providing commentary. "Why the stenciled shocks of wheat?!" he would exclaim, and I would unpack the metaphor. "Why weeds in jars!" he would shout, shaking his head with laughter, and I would discourse on the

whole weeds-in-jars thing. Eventually, Billy Jack began to realize that these sessions were helping him at work, that they were, in fact, invaluable. I flatter myself by believing that they might have been critical, because I wanted the best for him, and when you do what Billy Jack did, which is minding the rich in the interests of culture, it helps to know who sends their daughters to Miss Porter's or to Madeira or wherever and why. It helps to know which headmasters at which schools were gay or straight, which were Latinists and which were closet Trotskyites.

Nobody is going to ask you *how* you know these things—if, perhaps, you learned them from a queen down on Jane Street. If you know, you know, and that means that you're very likely "solid"—a "solid man, that Manfredi"—that's the sort of thing they say and that's the way they talk, which is the way my dad talked, although I was never suspected of being a "solid man." Billy Jack, however, actually *was* a "solid man" and a good scholar, too. A firm grounding in the art and material culture of Western civilization, however, ranks about twenty-seven on the list of qualifications for his job, and before he met me and married Maureen, that was all he knew. He had a Doctorate in Art History from Penn, where he attended on scholarship and worked road crews in the summer. He knew all there was to know about German silver, and that, he said, counted for exactly diddley-squat, although that was why he was there and why he loved it.

Sometimes, when he was working late, I would show up at the great museum and he would buzz me in. We would walk the long, dark corridors, listening to our footsteps echoing through the marble rooms as we strolled. I found this pretty creepy, but Billy Jack loved it. He would touch things, just barely grazing them with his fingers as we passed and, at least

once per tour, he would look over at me and say, "How lucky am I, James? As a kid, all I ever wanted was just *one thing* that wasn't fake—one thing that didn't fold up for easy transportation. That's it. Just one real thing, and now I have *millions* of real things and they aren't going anywhere. They're staying right here."

One night when we were on this subject I asked him what his parents would have thought if he'd showed them the great museum.

"They would have stolen something," he said, "Nothing big, you understand. Mom and Dad were small time from jump street, but Monty would have palmed a Roman coin, something like that. I know he would have tried. He couldn't not try."

Monty was Monty Manfredi of "Monty and his Amazing Cockatoos." His mother was Gloria Manfredi, who worked in the show with Monty, and, who, according to Billy Jack, had spectacular tits and never lost her looks. "I came into her room at the Tropicana that morning and found her in the king-size bed," he said, "And she was clearly gone. I could tell that by her color, but she was still beautiful, you know. She was really a beautiful woman. I took her works, the needle and the rest of her junk down the hall and threw it down a garbage chute before I called security."

"Where was your dad?" I asked.

"Who knows? He showed up about noon, still in his tux, smelling like bird shit. He always smelled like bird shit. Two days later we headed out for Tahoe with an ex-dancer named Tanya who had bigger tits than Mom but they weren't as good, and she wasn't nearly as beautiful."

"I notice that Maureen has modest breasts," I said, trying to make a joke.

"Jeeeeezus," Billy Jack said, grinning tightly and shaking his head as if he were about to cry, "Do I *need* this?"

"No you don't," I said. "I'm really sorry."

"That's okay," he said. "I love you, Sandy." That was his name pet for me: Sandy, as in Sandy Dennis, a joke.

Even though he didn't like to talk about it, I would pump him for stories about his childhood because it sounded like heaven to me, the trips, the hotels, the clubs, the showgirls and chorus boys, the barrooms in the morning, the fact that "Monty and his Amazing Cockatoos" never played Connecticut. Even Billy Jack's education in the arts sounded romantic to me.

"In the summers," he said, "when they couldn't stick me in some dangerous, inner-city school, and I didn't want to hang around the hotel, I would spend my days in museums. They were my real homes. I would dream about living in them the way some kids dream about living in department stores. I liked the museum in Cleveland, the one in Pittsburgh and the one in Baltimore. Those were my favorites, and think about it, James, think about spending the whole *day* in a museum, five days a week. In a day, you can read every label and see everything two or three times. In a week, you can get into connoisseurship. You can decide on your favorites, your second favorites, and decide on those special things you like but nobody else much does. That's how I got into silver. Nobody seemed to care about it that much. The rooms were always empty so I liked to keep the silver company."

"You understood that," I said, "not being cared about."

"Oh fuck you," Billy Jack said.

During the fall and spring, Gloria would always put Billy Jack in school, sometimes in as many as three schools a year. Sometimes he would come back to a school he had attended for three weeks, during a short engagement, two years later.

"I'll say this for my primary and secondary education," Billy Jack would say, "It confirmed everything Darwin has to say, because every time you came to a new school one of two things would have to happen. Either you beat the shit out of some little kid, right away, or some big kid would beat the shit out of you. There had to be a fight, you see, so you could be located in the primitive pecking order. But I *hated* beating up little kids. I did it, but I hated it, so I would sometimes put it off. I would think maybe it's going to be okay this time. But it never was. If I waited too long, some big kid would kick the crap out of me.

"One time, I remember, I waited too long and the weirdest thing happened. I had been putting off beating up this little kid. I had picked him out but I hadn't stomped him yet, and, oh Jesus, the biggest droog in the whole schoolyard comes up and starts one of those pushing 'I dare you' things, and I don't know what came over me. The first time he touched me, I punched him in the face. I then proceeded to flail the bejesus out of him. All of a sudden, James, I was *king* of the schoolyard and, I hate to tell you, but it felt fucking great. I walked around with this swagger. So I always wonder what would have happened if I stayed at that school, if we hadn't packed up three weeks later? What if I went all the way through school as *king*? It would have changed my life, I think."

"I think it changed your life, anyway," I said.

"How so?" he said.

"You're a museum director," I said, "Your father hid birds in his coat."

I will always remember that moment. We were sitting up in bed in the dark, and the light was coming from the street. I saw Billy Jack frown a little and then smile. Then he smiled even more. "I love you, Sandy," he said, "Nobody else would have explained that to me, and if you hadn't, I would never have known. I *never* would have thought of it that way. I was just running for a safe place, but you're right: I'm a museum director. My father hid birds in his coat. That's something, isn't it?"

"It's something," I said, and now I wish I'd said something more. The whole time we were together, I always respected his distance, his other life. I always said that I wanted him forever, but not all the time. That was our joke, but it was a lie. I wanted him all the time, all day, every day. I knew that from the start and now that our forever is over, it doesn't make any difference what I didn't say. It would have probably ruined things anyway.

11.

AQUARIUS

I am going to explain this to you very simply. All human creatures are divided into two groups. There are pirates, and there are farmers. Farmers build fences and control territory. Pirates tear down fences and cross territory. There are good farmers and bad farmers, good pirates and bad pirates, but there are *only* pirates and farmers, and they are very different kinds of people. Some pirates do not mind farmers and even recognize their importance. As Roger Miller, a famous pirate, once wrote, "*Squares make the world go round/Government things can't get made do/by hipsters*

wearing rope soled shoes." Farmers, on the other hand, *always* hate pirates. What's more, farmers always *recognize* pirates even when the pirate being recognized has yet to recognize him or herself *as* a pirate. One of the ways pirates come to recognize themselves, in fact, is through their being persecuted as farmers.

If, whenever you enter the territory of some farmer friendly enterprise like the Department of Motor Vehicles or the Student Union at the University of Alabama, everyone glares at you sullenly and surreptitiously checks their wallet, you may be a pirate. If you think you're a pirate, you probably are, but you should check it out. Commit some petty offenses: park in a handicapped zone, jay walk, refuse to return the attached form in triplicate, or just take an "Incomplete" in Hegel and His Times and then never write the paper. If these transgressions don't get your panties in a bunch, it's a pirate's life for you. Embrace this moment of self-awareness and get on with your life. You are not, after all, the *only* pirate in the world, and remember this: *pirates are born and not made.* It's not something your mother did to you. It's not something the government did to you, or any of those amazing things Counselor Rick did to you at summer camp. You were *born* a pirate! Raise that skull and crossbones and sail away!

Always remember that one of the chief causes of personal unhappiness in the US of A, where farmer culture is all but hegemonic, is the denial of pirate identity. Farmers always know who they are. Pirates don't always, and very often the children of pirates, who are in fact pirates themselves, seek to deny their piratical natures and "pass" as farmers in order to rebel against their pirate parents. This rarely works out well in the long run. Take the case of Melinda. She grew up during the nineteen fifties in a pirate family

who were also hard-line communists. As a consequence, Melinda grew up hating communism, which she associated with people smoking cigars and shouting about fascism in the kitchen while Aunt Tilly played old 78s of Mahler symphonies at top volume on the phonograph when Melinda wanted to play Ruth Brown and the Clovers. This set of circumstances led Melinda to associate being a pirate with being a communist.

So Melinda resolved to become a farmer. In her sophomore year at Berkeley, she met a young man from Wisconsin who had renamed himself Earth Free. He wanted to be a farmer, too, so they moved to Oregon to be farmers together. Fortunately, they almost immediately came upon a commune called Free Earth, which they took as a sign and joined forthwith. Here they lived happily in a disabled school bus. They smoked marijuana cigarettes, had group sex and did very little farming at all. In this way, by virtual happenstance, Melinda's pirate nature was able to reassert itself. Things did not turn out so well, however, for Melinda's daughter J.L. (Janis Lives). Having grown up naked and dirty in a bus, sorting seeds and stems, and listening to Electric Flag and Canned Heat, J.L. came to associate being a pirate with being a hippie, and she *really* hated hippies.

Thus it was that, when J.L. herself finally matriculated at Berkeley, she immediately became a communist, only this time the communists were not *pirate* communists, they were *farmer* communists—tenured communists with an infrastructure of ideological imperatives and dietary laws that made your average orthodox Shi'ite community look like a Rolling Stones concert. Almost immediately J.L. was caught smoking. Then, not long thereafter, in a rebellion against a childhood of tofu and sprouts, she was observed scarfing down a Big Mac. From there it was only a short step

to the ideological heresy that got her ostracized. This involved a sex act employing an object that could only serve to perpetuate the obsessive commodity fetishism of late capitalist culture. Today, J.L. works as a dental assistant in Encinitas where she is not a happy camper. This demonstrates a common fallacy: that of associating the eternal distinction between pirates and farmers with the petty local distinctions that have defined political ideologies in the twentieth century.

We can't be any more firm on this point. There are right-wing farmers and left-wing farmers; there are right-wing pirates and left-wing pirates, but there are *only* pirates and farmers. The good thing about farming is that it keeps you busy at home and pays steady. The good thing about piracy is that it is fairly cosmopolitan; you get to move around and when it pays at all, it pays *very well*. This might seem a fair enough trade-off, but it often spells doom for the extremely competent pirates who, having amassed mountain ranges of doubloons, gold bullion, jewelry and brass cannon find themselves feeling peckish and down in the mouth from all the aggressive rushing about that is intrinsic to the pirate lifestyle. They find themselves, say, driving down US 30 through Arkansas with their pirate crew. Glancing over to the side of the road, they see this beautiful horse farm with white fences and green pastures full of elegant thoroughbreds. The animals' slick coats are gleaming in the sun. There are pristine, white, colonial-style stables, with cupolas and weather vanes and, way back there in the trees, at the top of a circular drive, just a glimpse of ante-bellum mansion.

Seeing all this, the successful pirate remarks to his pirate crew: "I've worked damned hard at piracy, you know, and worked damned long. I've raped, pillaged, plundered and sent many a king's man to a watery grave, so

why shouldn't I seek some refuge and respite. Why shouldn't I retire to a horse farm just like this. I have enough money to buy it in a baggie rolled up in my boot." At this point one hopes that the successful pirate's hearty comrades will speak up firmly, that they will say:

"Your pirates ain't your farmers, Cap'n, sir. Farmers *hate* pirates something fierce, and even if you buy a farm, consort with animals and wear a farmer hat, they will know you for a pirate. They will mobilize, take action, and what do pirates know of down-home farmer fighting? Of farmer martial arts? Of water districting, tax assessing, zoning, easements, and such? What pirate with a single *cojone* knows dick about subcontractors, plumbing contractors or any other kind of contractor? About condemnations, imminent domain and rights of way? To be honest, Cap'n, your forthright pirate way of fighting would be naught but child's play to them. They would run you down in the road, steal you blind, sue you till your toes hurt, and, worst of all, *you could not sail away!* You would be stranded there, becalmed on this farm in the middle of nowhere, and even if you overcame all these obstacles through the auspices of a corrupt farmer lawyer, you know what they would do? They would shoot your dog and burn your horses in their stalls."

12.

PISCES

In the mid 1960s, when I was still in my old studio over by Notting Hill Gate, a musical acquaintance of mine (now retired to St. Croix) used to drop by at the odd moment for a glass of spirits. Usually, he'd come storming in at the crack of dawn, his black hair flying like a shrub in the midnight

CASINO

RAMP FOR
PISCES
ONLY

wind, still up from his gig the night before. Bothered and hotly distracted, he would knock back three fingers of my Irish, collapse on my flowered couch, and sit there all morning with his elbows on his knees, hanging his head and fretting about his mates in the band.

"Oh dear, oh dear, Dev," he would say, "I fear these boys are as doomed as they are crazy. They have no future in their eyes and no proportion in their hearts. Yet here we are, fookin' *pop stars!* We got two records on the charts, gigs from here till Christmas next, and what are they doing? They're *ruining* their fookin' lives! They're dying, I think, of just wanting *everything*, and I tell them: 'Lads, you can't *have* everything! *Everything* doesn't exist!' 'Cause they're me mates, y'know, and it's my band, I can't help but feel they ought to be getting *something* out of this. But are they? Can they? Oh no! They're off to Princess Big Tits' for the weekend. They're having tea with David Frost! All the money we made last year and what do they have? Victorian cavalry jackets and bloody noses, and, by God, Dev, it's like they're dying of *hunger*."

"And here you sit before me," said I with a large gesture, "the very image of calm satiation."

"Well, maybe not, but I'll say one thing for little Ian here: when he started his fookin' band, he wanted one thing: a car, but just wanting a car was nay enough for him. He had to know *which* car and how dear it was. So, before they even played a gig, he set out car shopping in his grubby north-country togs. Right into the finest establishments did he go, one after the other, 'til he finally found the car he wanted, specifically, exactly: a metallic-green Lamborghini Miura, butterscotch leather interior."

"How amazing," I said, "There's one parked right out in the lane!"

"The very automobile," he said, "and, not only that, for a whole year and a half, little Ian had no doubt. He knew exactly what he wanted. Then he got it, and felt the satisfaction of getting it. Then he could start thinking about what he wanted next."

"And what is it that he's wanting now?" I asked, vastly amused.

"He wants to retire to an island and spend the rest of his life reading Fielding, Dickens and Trollope," he said, "and maybe D.H. Lawrence."

"And how is he doin' on it?" I asked.

"The collected works of all these authors," he said, "are boxed up at his Gran's, ready to ship."

"Ah, Ian," I said, grinning at him, "You are the crazy poet of my heart."

"Crazy drowns in its own puke," he said, unamused.

After that morning, since I myself have been vulnerable to the indiscriminate wanting of everything, I gave serious thought to Ian's view of things, but it wasn't easy. First, I had to admit that I *did* want everything, and that, even more than that, I wanted back at *everybody*. And even knowing this, it took me two years to figure out exactly what I wanted. By that time I was living in New York, which wasn't it. What I wanted, specifically, exactly, was sunshine and a net. The sunshine is easy, since it has ever been my contention that the whole of my life's labors have been devoted to correcting the mistake of a chauvinistic Irish stork, who, when instructed to deliver wee Devon to the West Coast, took him to the west coast of bloody Ireland. Thus was I born longing for the sunshine, a commodity of which Galway has little on hand in the best of times.

Even the art for which I am justifiably renowned—the art which, according to the most learned critics at Yale University, deals with the

problematic ontology of artificial illumination and the palpable presence of negative architectural space—is really naught but sunshine by other means—interior sunshine, but sunshine nevertheless. The desire for a net might seem more opaque, because it sounds a bit self-serving to be wanting a net. Actually it only seems opaque because it is, in fact, self-serving. In my own defense, I can only say that I never *thought* of wanting a net until I moved to the island of Manhattan as a promising young minimalist whiz kid and quickly discovered, much to my amazement, that everyone else who was flying through the air with the greatest of ease had one—and no wonder I was so bruised up. I felt like a complete wanker.

Somehow, in the grip of some mad delusion, I had gotten the whole art thing wrong, thinking it to be something for which one risked everything— thinking, also, that it was something for which Ian and his band mates might have some sympathy, where you went in to the shed behind your Da's semi-detached and came out with something bloody amazing. It wasn't that at all, of course, but how was I to know? Growing up amidst the fog on that wee asphalt street in Galway, the world beyond the west of Ireland was magazines, films, and pictures on the telly. I pored over them, reading about singers, dancers, painters, writers and musicians. I looked at the pictures, and everything these creatures did looked so astoundingly *brave* that I was fearful for them just looking.

The very fact that human beings would launch themselves out like that, upon nothing but their own conviction, was so daunting to me that I spent the better part of my youth simply steeling myself, so I might possibly call upon that kind of courage when I needed it. Then I came to New York, already well along in my career, already a practicing adult artist of the most

advanced breed, and only then did I realize that all those pictures, the ones that had fed my fantasies, had been cropped. All you saw was the amazing lady in her spangled tights flying through the air. You didn't see the net. The nets had been cropped out, so, *naturellement*, all I perceived upon my arrival in Manhattan was nets. The whole island, block by block, seemed to be strung with nets designed to break the falls of privileged children who routinely flung themselves from windows well assured that they would never hit the street.

Everyone I met, all the other promising young minimalist whiz kids, had nets—a rich aunty in the woodwork, a grant, a trust, a sinecure, a stipend, and a loft—had a mentor at the Modern, a rabbi at the Times, and a daddy on the board at Yale. I met lads whose daring I had worshipped and discovered that, far from being daring, they were simply well-off, well-educated, well-connected and extremely well-organized. And, believe me, my anger had naught to do with their work. The work is always what it is regardless of what idiot makes it. It had naught to do with anything, in fact, but wee Devon's child-like longing for like-minded mates, for other fools who had flung themselves out there, who had plunged down the vertical face of the same great wave. If there were any to be found, I surely never found them. I seemed to be the only fool in town and no more a part of their cozy American art adventure than the poor, illiterate, malnourished sods who shambled off the boat in Black Forty-Nine.

I had been looking for some heavenly confluence of rebel angels. What I found was the Victorian Church of England, a well-protected game preserve for the extraneous progeny of the la-di-da classes—for its second sons and wayward daughters, its soft-core geniuses and spiritual tipplers, its obsessive

diners-out and genteel poofters. 'Twas a devastating discovery, to be sure, but well inured I was to devastation, so the work went on. Like Yeats' airman, I sought my fate among the clouds above. I could not hate those whom I should, nor love those I should love, but I came to terms. By day, I labored in the gloom of New York, in the majesty of my personal sunshine. By night (now knowing where I was), I romanced the vicars over drinks, lengthy dinners, and whenever appropriate, in the sack.

Casting my shame aside like an old football shirt, I proposed enormous projects to institutions all over the face of the earth, and most of them, to my enormous anguish and surprise, were funded. For ten years, I lived on airplanes, among the clouds above. I hired assistants to do the work, secretaries to handle the paperwork, and gradually found myself transformed into an enormous, petulant baby, spitting up on my chin and whining about hotel menus, connecting flights and museum curators. Then, suddenly, for meritorious service at dinner parties and in the sack, I was issued my net. In early 1985, within the space of three short months, I received a stipend in perpetuity from a New York foundation, a "genius" grant from yet another confluence of inherited capital, and a shamelessly large cash award from the Irish government, who up until that moment had taken no notice of me whatsoever.

At this point, I should have just quit, but middle class sod that I am, I played out the string, fulfilled my existing obligations over the next four years, concluding with a heart-stopping, and totally heartless *pièce de résistance* at a biennale in Istanbul. The next day I flew from Istanbul to Shannon, drove down to Cork and purchased the infant Muldoon from my first cousin, Mary Iris Clare, who breeds beagles and prefers dogs to

humans (as, by that time, did I). Leaving Muldoon in Mary Iris' care, I flew from Shannon to San Diego, purchased my little house on the hill above the ocean and sent for Muldoon, who arrived disheveled and somewhat the worse for wear. Then I took a well-needed break and waited for the urge for making art to fall upon me again, as it always had. But it never did, and I am tired beyond weeping of being asked why. All I can say is that whatever art I might make now would not be brave enough, nor joyful enough, nor matter enough, and even if it were and did, no one would even notice.

So, this is the last you'll hear from the likes of us. From this day forward the artist, Devon Clare, and his constant companion, Muldoon the Beagle, shall remain incommunicado. We are officially "out of touch," and should this declaration sound a wee bit ominous, please be assured that it bespeaks no real despair. We plan no drastic action. We shall, instead, rise up every morning and breakfast on the redwood deck of our little house on the hill above the ocean. While Muldoon noisily inhales his Science Diet, I will sip my tea and enjoy the misty prospect of downtown Ocean Beach—its grid of low buildings and scruffy palms, its deserted pier. I will scan the beach, as well, and, if the surf is up, perhaps, I'll snag me bin's and eye the lads and lassies on the waves. Otherwise, I'll gaze upon the gray Pacific and read the morning news.

Later in the day, I will attach Muldoon to his leash. We will stroll down to Dog Beach where, once unleashed, Muldoon, like the great Irish hero, Cuchulain, will do battle with the sea, chasing every retreating wave down the slope of wet sand with noisy yelps, then scrambling back in terror before its powerful, boiling return, and then, as the wave peters out on the beach, turn with renewed courage to attack again. Muldoon is capable of

skirmishing with the surf in this manner almost indefinitely while calm Labradors and Shepherds gaze on in wonder and bemusement. Muldoon is a foolish animal, but I love him all the more for knowing that he actually believes, with all his beagle heart, that the ferocity of his galloping attack is actually *driving* the wave down the beach until it can retreat no farther and must retaliate in force, which it does, only to lose heart when faced with the intrepid Muldoon standing stern and stiff-legged on the dry sand, just beyond the wave's watery reach.

I watch this daily contest with interest and take the lesson from it, because Muldoon's delusion and the comedy of it are not alien to me. Many's the evening I've shouted the sun down into darkness, and many's the morning I've summoned it forth, but no more. I am done. I am where I would be and shall go no further. I will walk the beach and chat with feral children in black wetsuits who drop their boards to pet his handsomeness, Muldoon. What they see is what I am: a frail white haired Irishman with bright blue eyes and a crazy dog, three thousand miles from home and home at last. So, I shall whine no further whines, because what I have, most people don't and what I've paid, most people do.

*

In honor of this tenth publication
of the Artspace Book Series
the publisher would like to dedicate these books
to the memory of her teacher
and friend Sam Wagstaff
[Anne Marie MacDonald]

ARTSPACE BOOKS IS A FORUM FOR
CONTEMPORARY ARTISTS AND WRITERS.
THESE COLLABORATIONS OF IMAGE AND TEXT BY TODAY'S
MOST INNOVATIVE ARTISTS CHALLENGE THE
CULTURE IN WHICH WE LIVE,
AND INSCRIBE THE VITAL SOCIAL
FUNCTION OF ART.